This book is given with love to my mom

Love You Mom:
The Perfect Anti-Stress Coloring Book For Moms

First published in the United States in 2015 by
Bell & Mackenzie Publishing Limited

ISBN: 978-1-910771-44-0

Created by Christina Rose

Contributors: Laura Vann, Shutterstock/troyka, Shutterstock/tets, Shutterstock/Chevnenko, Shutterstock/Fears, Shutterstock/Tatiana Akhmetgalieva, Shutterstock/geraria, Shutterstock/IrinaKrivoruchko, Shutterstock/Daiquiri, Shutterstock/ Dychek Marina, Shutterstock/Elena Mazhulina, Shutterstock/HelenaKrivoruchko, Shutterstock/Natalia Toropova, Shutterstock/An Vino, Shutterstock/worldion, Shutterstock/ abdrashitova svetlana, Shutterstock/Analia26, Shutterstock/ Zhenya Ma

www.bellmackenzie.com

When your mother asks, 'Do you want a piece of advice?' it is a mere formality. It doesn't matter if you answer yes or no. You're going to get it anyway.

Erma Bombeck

But there's a story behind everything. How a picture got on a wall. How a scar got on your face. Sometimes the stories are simple, and sometimes they are hard and heartbreaking. But behind all your stories is always your mother's story, because hers is where yours begin.

Mitch Albom

The only love that I really believe in is a mother's love for her children.

Karl Lagerfeld

In a child's eyes, a mother is a goddess. She can be glorious or terrible, benevolent or filled with wrath, but she commands love either way. I am convinced that this is the greatest power in the universe.

N.K. Jemisin

But kids don't stay with you if you do it right. It's the one job where, the better you are, the more surely you won't be needed in the long run.

Barbara Kingsolver

Children are knives, my mother once said. They don't mean to, but they cut. And yet we cling to them, don't we, we clasp them until the blood flows.

Joanne Harris

The best place to cry is in a mother's arms.

Jodi Picoult

No one is ever quite ready; everyone is always caught off guard. Parenthood chooses you. And you open your eyes, look at what you've got, say "Oh, my gosh," and recognize that of all the balls there ever were, this is the one you should not drop. It's not a question of choice.

Marisa de los Santos

My mom smiled at me. Her smile kind of hugged me.

R.J. Palacio

A mother's body remembers her babies-the folds of soft flesh, the softly furred scalp against her nose. Each child has it's own entreaties to body and soul.

Barbara Kingsolver

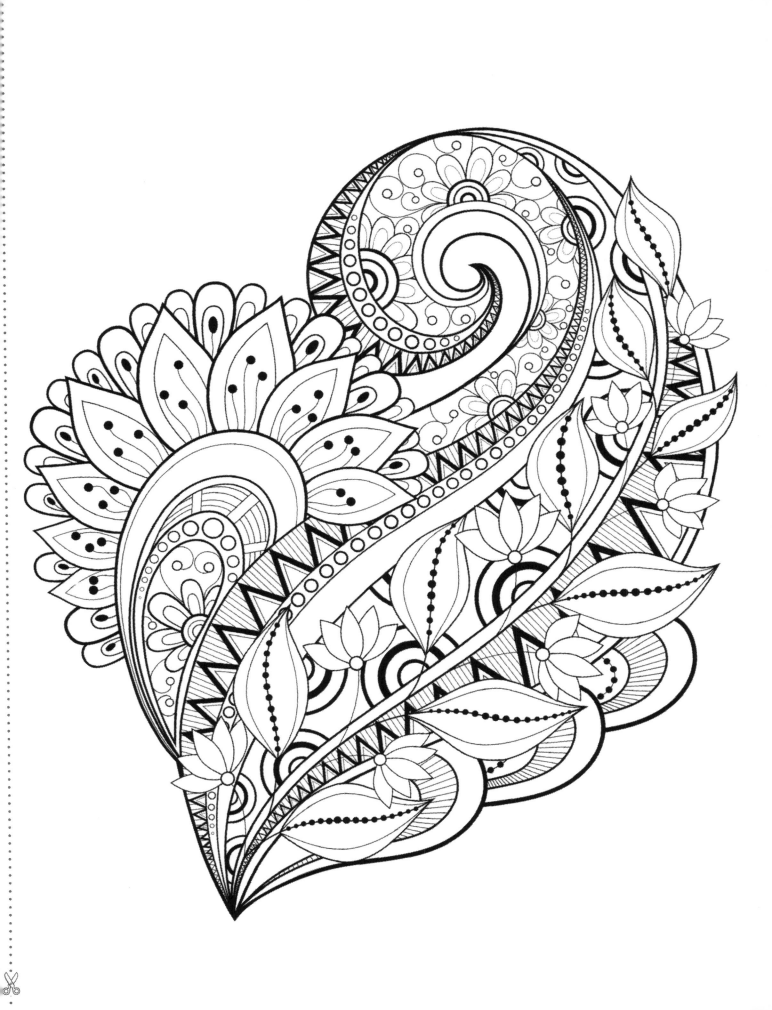
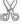

I like it when my mother smiles.
And I especially like it when I
make her smile.

Adriana Trigiani

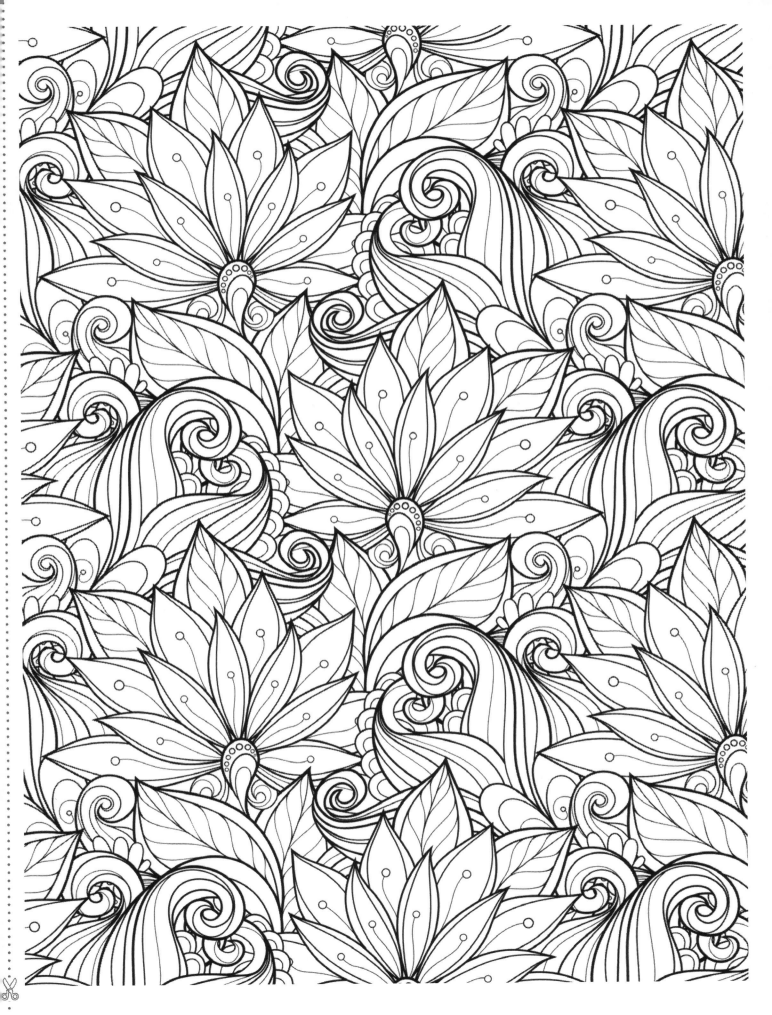

A mother is a person who seeing there are only four pieces of pie for five people, promptly announces she never did care for pie.

Tenneva Jordan

Being a full-time mother is one of the highest salaried jobs in my field, since the payment is pure love.

Mildred B. Vermont

I remember my mother's prayers and they have always followed me. They have clung to me all my life.

Abraham Lincoln

All women become like their mothers. That is their tragedy. No man does. That's his.

Oscar Wilde

An ounce of mother is worth a pound of clergy.

Spanish proverb

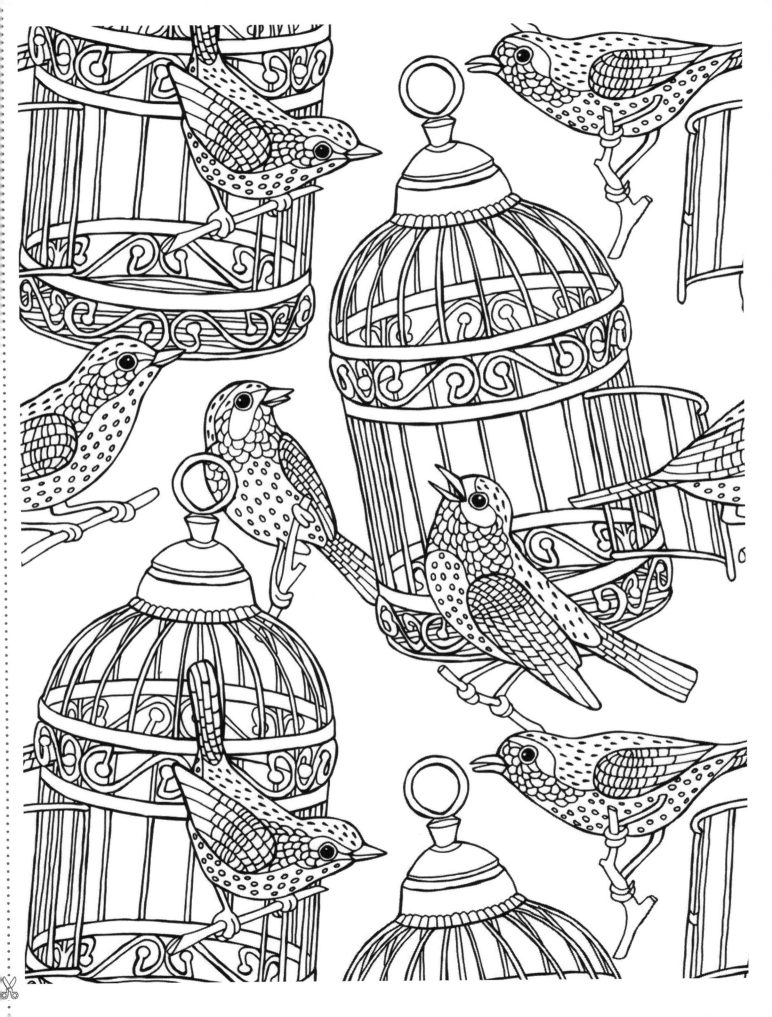

She never quite leaves her children at home, even when she doesn't take them along.

Margaret Culkin Banning

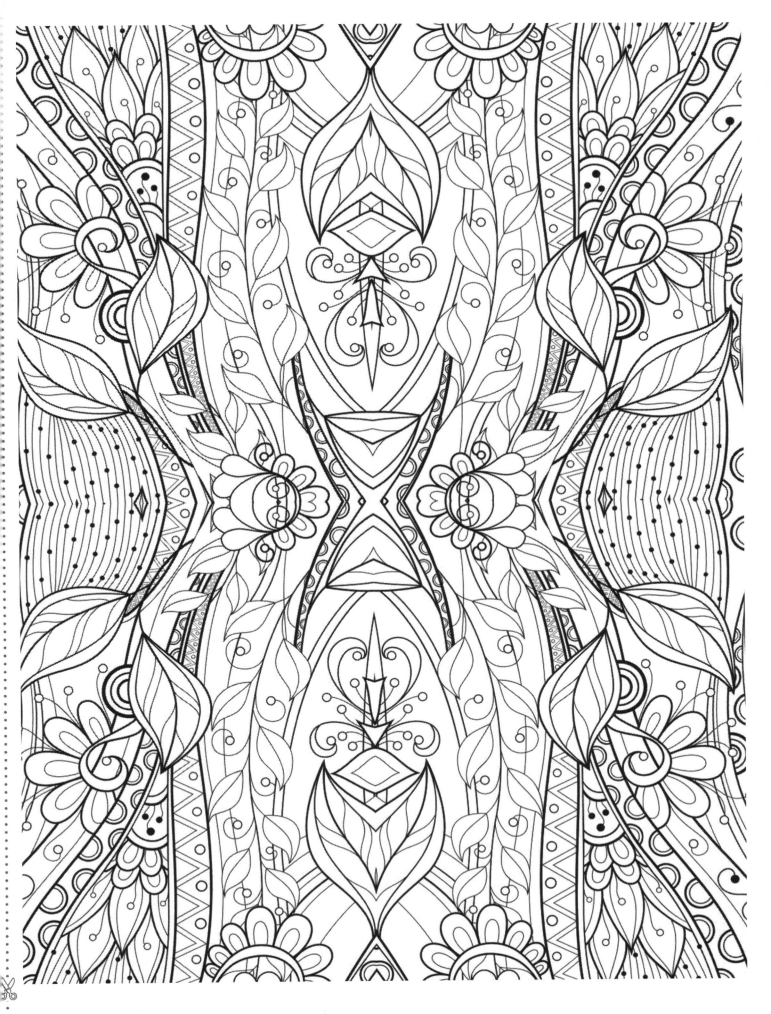

Motherhood has a very humanizing effect. Everything gets reduced to essentials.

Meryl Streep

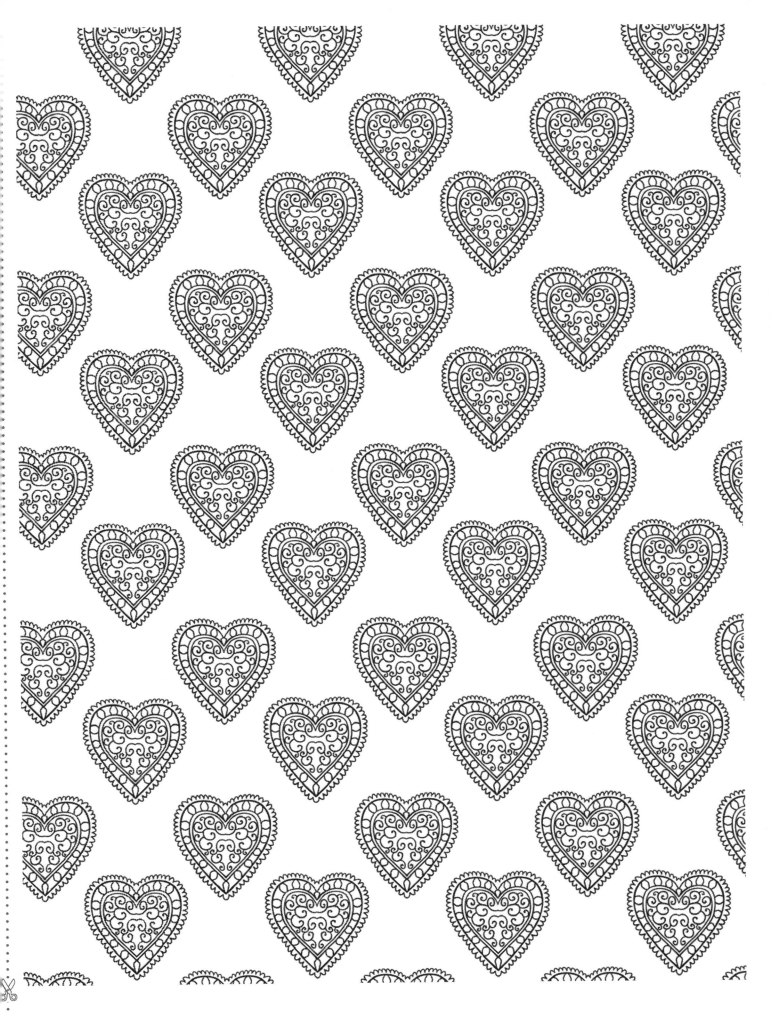

In all my efforts to learn to read, my mother shared fully my ambition and sympathized with me and aided me in every way she could. If I have done anything in life worth attention, I feel sure that I inherited the disposition from my mother.

Booker T. Washington

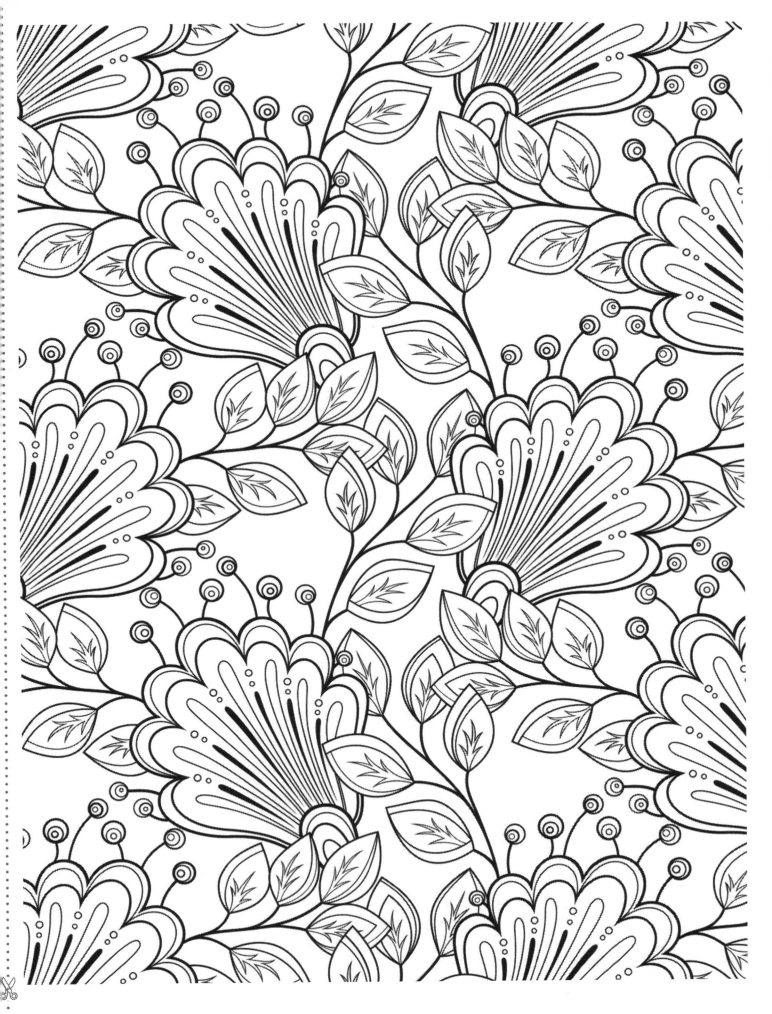

Any mother could perform the jobs
of several air traffic controllers
with ease.

Lisa Alther

There was never a child so lovely but his mother was glad to get him to sleep.

Ralph Waldo Emerson

Motherhood is neither a duty nor a privilege, but simply the way that humanity can satisfy the desire for physical immortality and triumph over the fear of death.

Rebecca West

No matter how old a mother is, she watches her middle-aged children for signs of improvement.

Florida Scott-Maxwell

I want my children to have all the things I couldn't afford. Then I want to move in with them.

Phyllis Diller

A mother is not a person to lean on, but a person to make leaning unnecessary.

Dorothy Canfield Fisher

A mother's love is patient and forgiving when all others are forsaking, it never fails or falters, even though the heart is breaking.

Helen Rice

A mother's arms are more comforting than anyone else's.

Diana, Princess of Wales

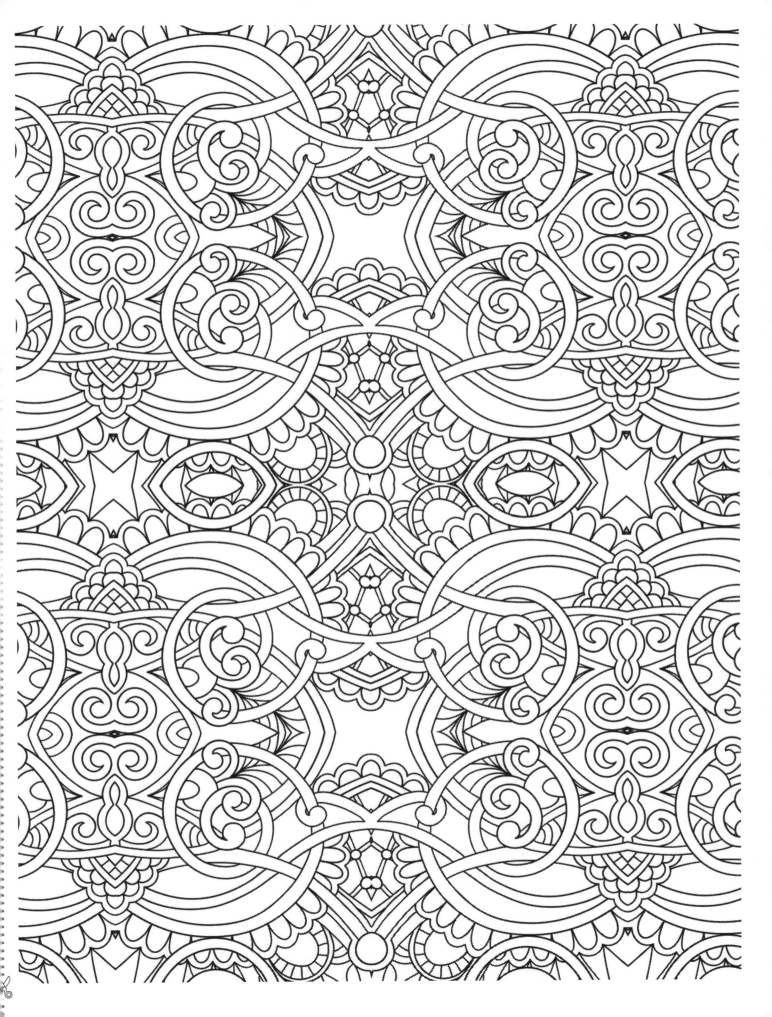

The hand that rocks the cradle
is the hand that rules the world.

W. R. Wallace

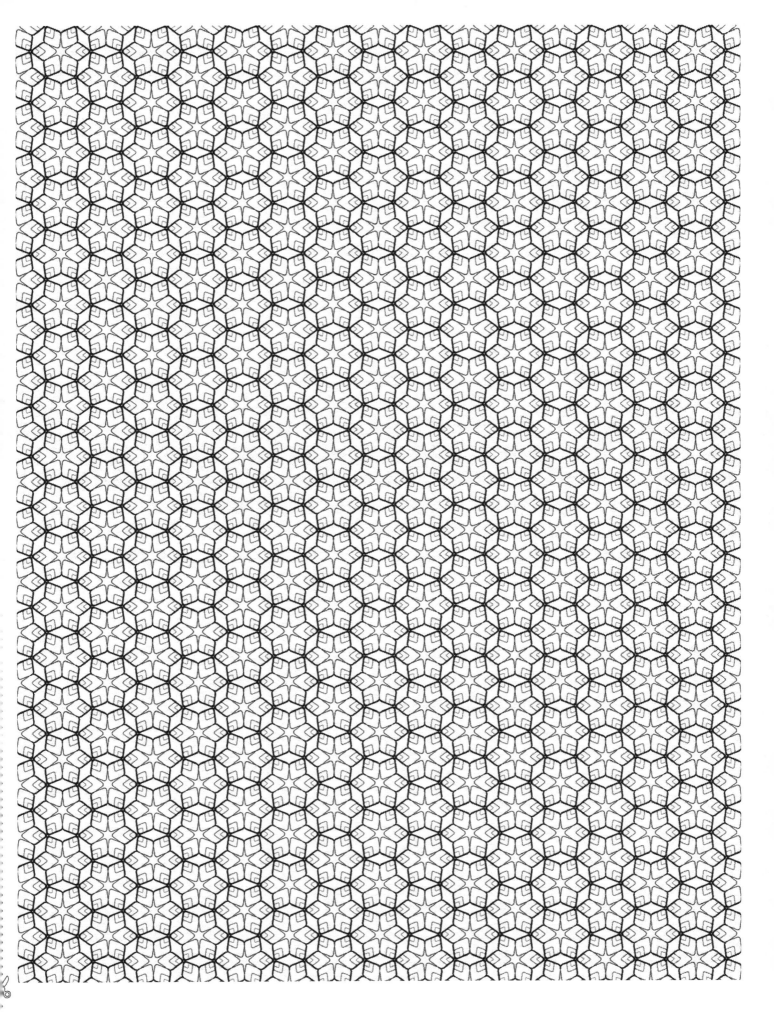

M

y mother was the most beautiful woman I ever saw. All I am I owe to my mother. I attribute all my success in life to the moral, intellectual and physical education I received from her.

George Washington

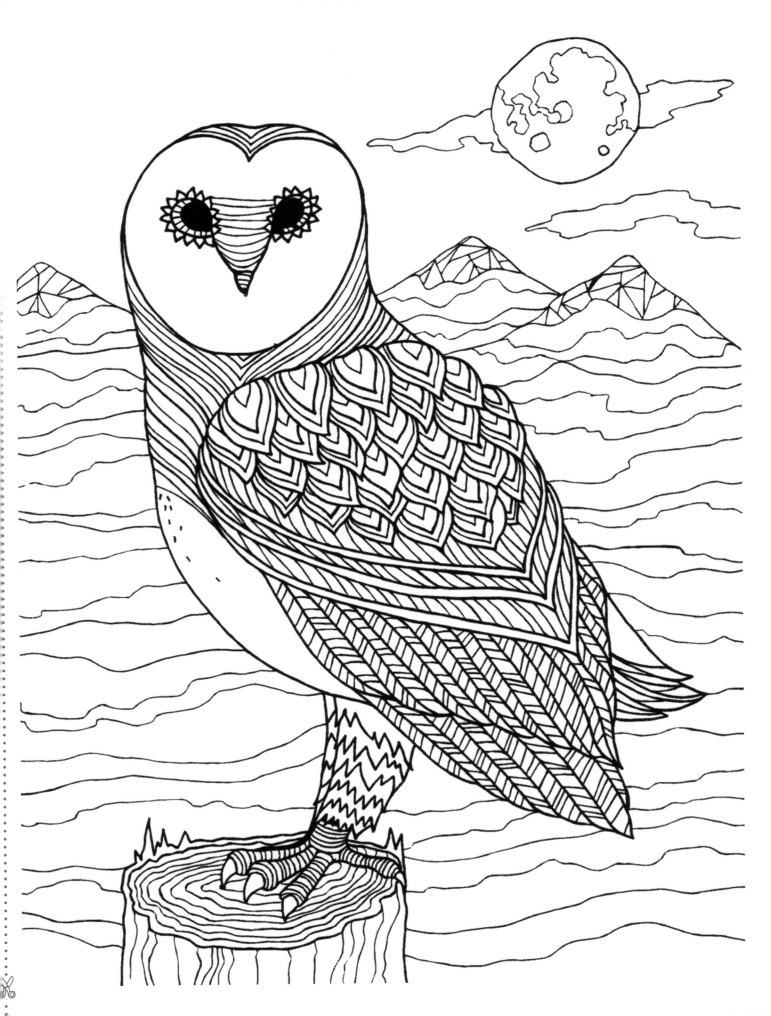

Motherhood is a great honor and privilege, yet it is also synonymous with servanthood. Every day women are called upon to selflessly meet the needs of their families.

Charles Stanley

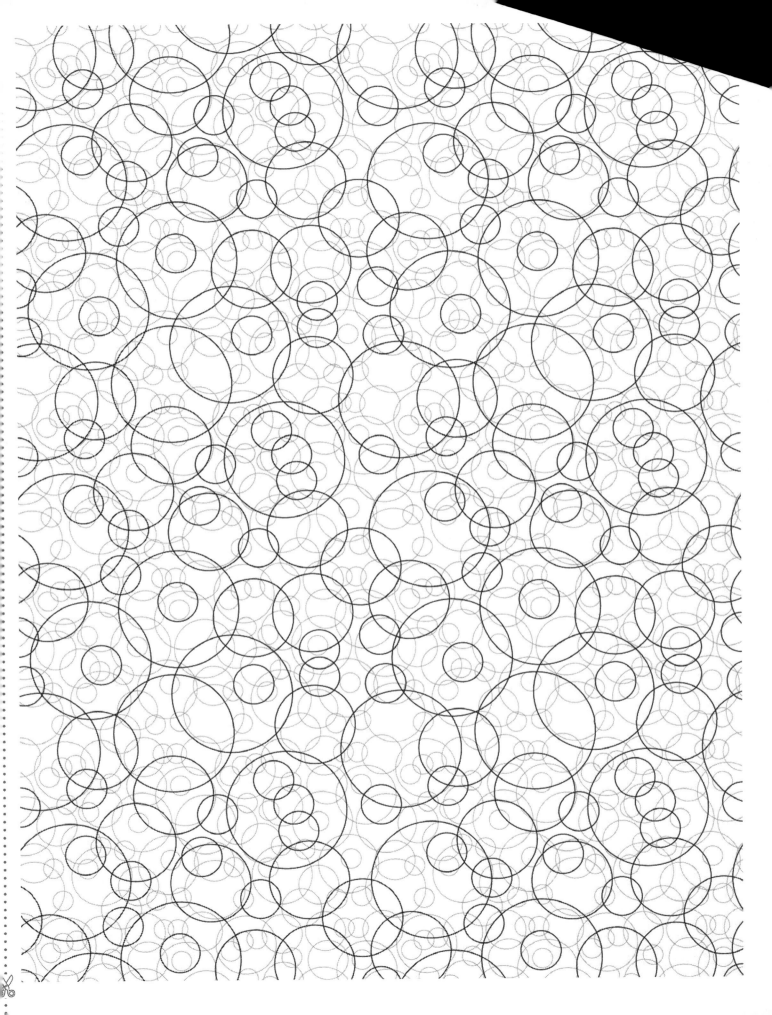

54280860R00038

Made in the USA
Middletown, DE
03 December 2017